Merry
Christmas
Linda!
I don't think much
of dogs, but I know you do.

Love,
Oliver
Dec. 25, 1997

A Dog's Life

A

Book

of

Classic

Photographs

BY THE
EDITORS
OF MAGAZINE

Little, Brown and Company
Boston New York Toronto London

With an introduction
by William Wegman

First Edition

ISBN 0-316-52691-6
Library of Congress Catalog Card Number 95-77659

10 9 8 7 6 5 4
RRD-OH

Published simultaneously in Canada by
Little, Brown & Company (Canada) Limited
Printed in the United States of America

PROJECT EDITOR: Melissa G. Stanton
PICTURE EDITOR: Debra Cohen
DESIGNER: Carol March

PICTURE SOURCES:
Bettmann: Dale Sedgwick
Contact Press Images: Frank Fournier; Jane Evelyn Atwood
Hamiltons Photographers Limited: Norman Parkinson
JB Pictures: Fritz Hoffmann
LBJ Library Collection: Yoichi R. Okamoto
Magnum Photos: Eugene Richards
Memphis Commercial Appeal: Bob Williams
Providence Journal: Raymond H. Nelson
Syndication International: Kent Gavin
TIME-LIFE Syndication: Officer John Martin, Santa Clara Police Department
Toronto Sun: Veronica Henri

A
DOG'S
LIFE

MAN RAY had been in my home no more than five minutes when I took his picture. He was on my bed, asleep, curled up next to a sock. It was 1970, and I did not want a dog. I was too busy being an artist. But I had made a promise to my wife that when we moved from Wisconsin to Los Angeles, we would get a dog—and a promise is a promise. So one day I came home with a seven-week-old weimaraner puppy that I had bought for $35.

AT THE TIME, I lived and worked in a large studio near Venice Beach, and I was photographing reconstructed scenes from everyday domestic life. Man Ray demanded my constant attention. He was always in front of me, and it became nearly impossible for me to take a photograph without him wandering into it. When I was working with props or other subjects, Man Ray would emit a high-frequency whine ("Look at me! Look at me!"), which drove me crazy. "He's ruining your life," a close friend said. It was true: little by little, Man Ray was taking over my life. I sometimes resented what was happening. More often, I liked it.

I'VE HEARD IT said that there are two kinds of photographs: those with dogs and those without—and the only good ones are those with dogs. I believe it. Dogs have a natural affinity for the camera. Every picture in this collection says so. Photos without dogs in them seem to lack something. Where's the dog? I don't see the dog.

MAN RAY KNEW he had a natural affinity for the camera. He was aware of the camera's presence and he knew to look directly into the lens at key moments instead of at me. Man Ray looked great on video and in photographs, and we worked together almost daily. Then, in 1978, as a New Year's resolution, I vowed not to photograph him for an entire year. I loved working with Man Ray, but I didn't want to exploit him. Man Ray, however, had become very serious about our work together. Posing for photographs had become his job, and now he was unemployed. It was a miserable time for both of us. We were back working together in 1979. Our photo in this book, *Ray and Mrs. Lubner in Bed Watching TV*, is one example of our work. (Man Ray is the fellow on the right; his costar is my sister's dog Lieba.)

IN 1982, MAN RAY died. I believed then that I would never photograph another dog. I missed Man Ray terribly, and I had dreams almost nightly that he came back to life. But I didn't miss having a dog: the responsibility, the lack of freedom. I was now able to reach for my house keys without being stampeded on my way to the front door. I even began to enjoy not having to always photograph a dog. But the dreams continued. In 1984, I got a dog from the pound, but he soon died of parvo. Then I got another weimaraner, a four-month-old puppy, and, tragically, he was stolen. After these two ominous incidents, I resolved never to get another dog. Man Ray, I thought, must not want it.

TWO YEARS LATER I gave a presentation of my work to the art department at Memphis State University. After my talk, a woman came up to me and told me that she loved my work with Man Ray, and that she bred weimaraners. Then, in a memorable Tennessee drawl, she said, "I would be honored if you took one of my puppies." "No, thank you," I replied automatically. But then, having nothing better to do that afternoon, I found myself saying that I would stop by for a visit. "Just to look."

SIX-MONTH-OLD Cinnamon Girl, whom I renamed Fay Ray, was soon living with me in the role of pet. Unlike Man Ray, Fay was skittish. Walking her on a leash along a New York City sidewalk was akin to walking a helicopter that had a damaged rotor. She was *everywhere*. The sound of grating metal would have her groveling in terror. There were many times when I thought of sending her back to Tennessee.

I DID NOT photograph Fay Ray at first. For some reason I couldn't. But within a year my resistance to photographing her disappeared, and I brought Fay to the studio and posed her against a red backdrop. I put a few plastic flowers on her and draped her in fabric. The photograph was hardly a stellar work. Fay, however, looked sublime. She was calm. She was attentive. Her yellow-ocher eyes beamed. Fay Ray and I have been working together ever since. Once a scared puppy, Fay now has great power and command. The photoflash, the studio setting, the repeat performances, the presence of assistants, friends and encouraging onlookers, have all contributed to her ascendancy. Meaningful work has given her stature.

IN 1989, FAY RAY had a litter of eight puppies, and I kept one: Battina. Battina is sexy and comic, a natural performer like Carole Lombard and a striking contrast to Fay's Joan Crawford. In my book version of the Cinderella story, the versatile Fay tackles the roles of both the Stepmother and the Fairy Godmother; the lovely Battina plays Cinderella. Two of Fay's other children—Chundo, a handsome, leonine male who lives with my sister, and Crooky, an impudent and bright-eyed beauty owned by a friend—are also eager performers. Crooky recently portrayed Goldilocks in a children's video; she was an excellent porridge stealer. When the foursome join forces, work and play combine into a joyful, whirling gray blur—one that has become even larger since Battina gave birth this spring to four pups. Seeing them all together makes me realize that I never again want to be without a dog.

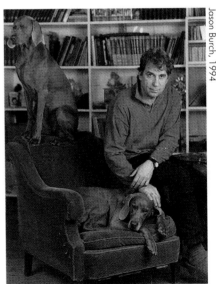

— WILLIAM WEGMAN New York City, 1995

BATTINA, BILL AND FAY RAY

GREYHOUNDS
MARCO ISLAND, FLORIDA
Frank Fournier, 1991

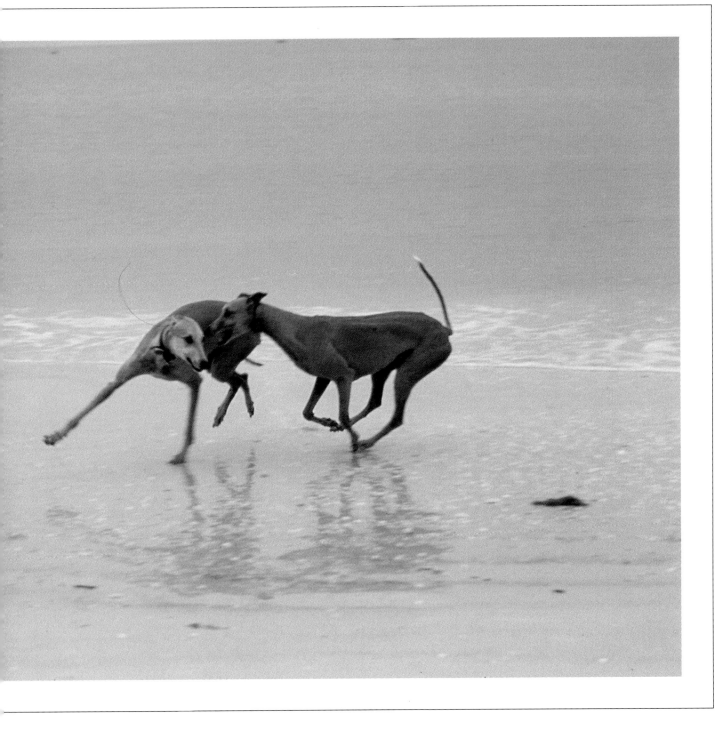

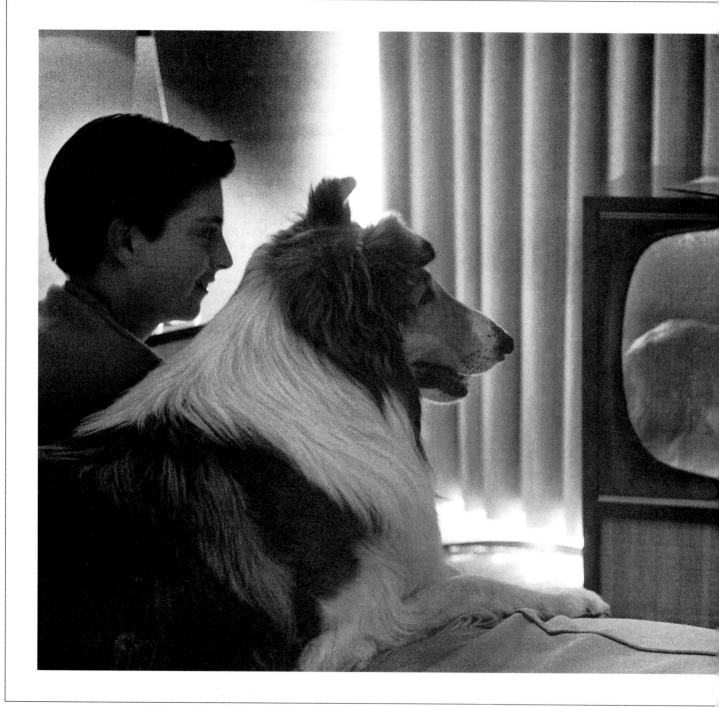

LASSIE AND COSTAR TOMMY RETTIG
WATCH THEIR FAVORITE TV SHOW
John Bryson, 1956

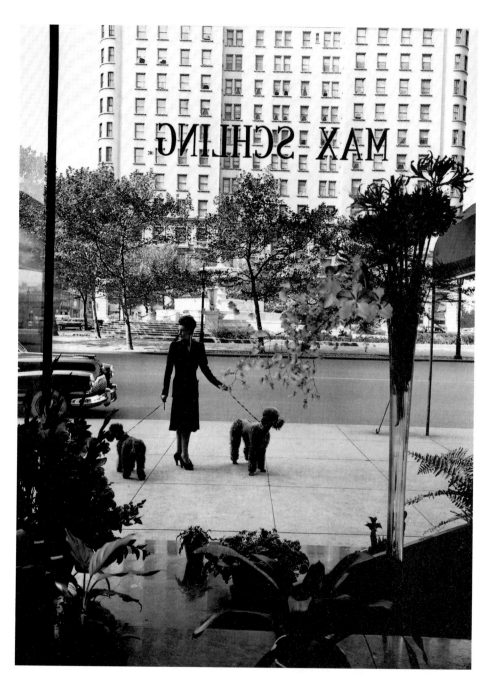

FIFTH AVENUE
SIDEWALK
NEW YORK CITY
Alfred Eisenstaedt, 1947

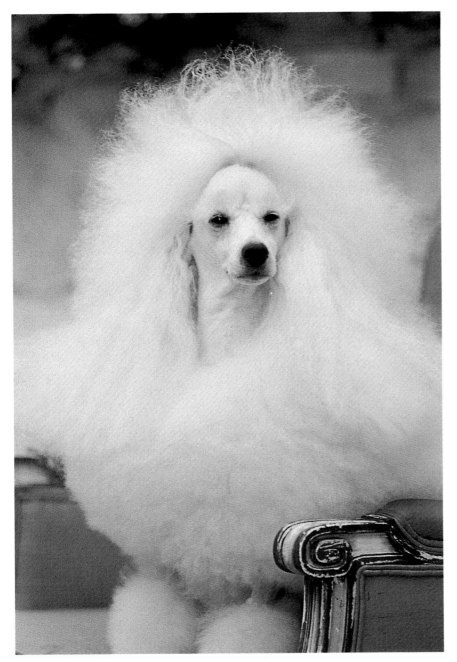

MINIATURE POODLE
CHAMPION TEDWIN'S TOP BILLING
Nina Leen, 1964

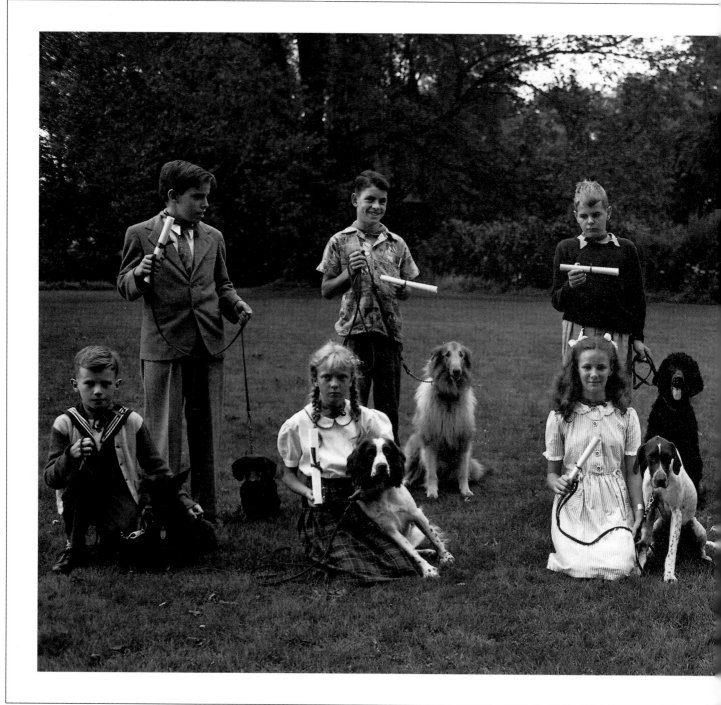

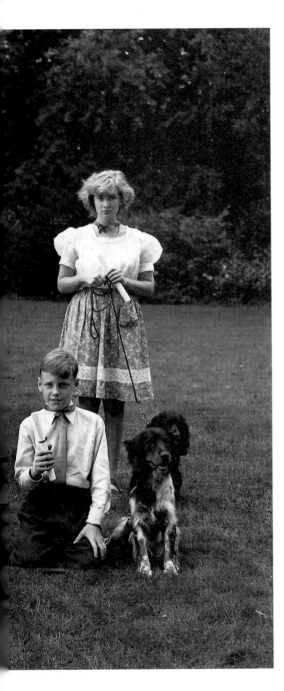

OBEDIENCE SCHOOL GRADUATION
Sam Shere, 1945

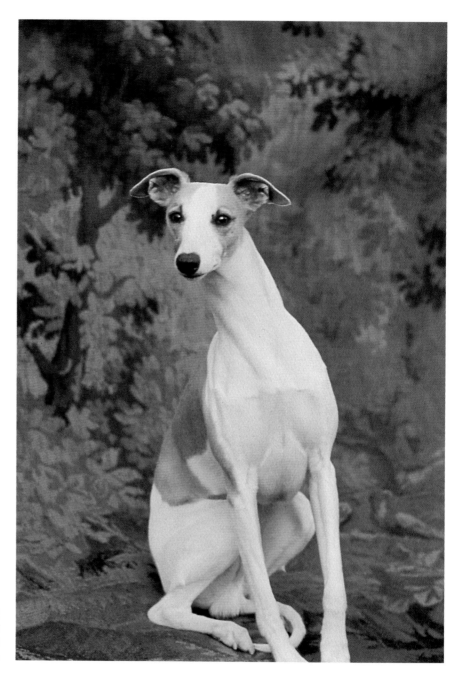

WHIPPET
CHAMPION COURTENAY
FLEETFOOT OF PENNYWORTH
Nina Leen, 1964

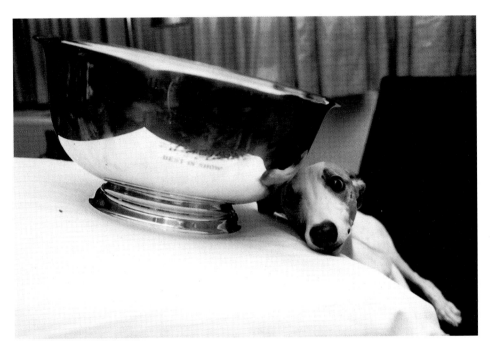

WEARY WINNER
Bob Gomel, 1964

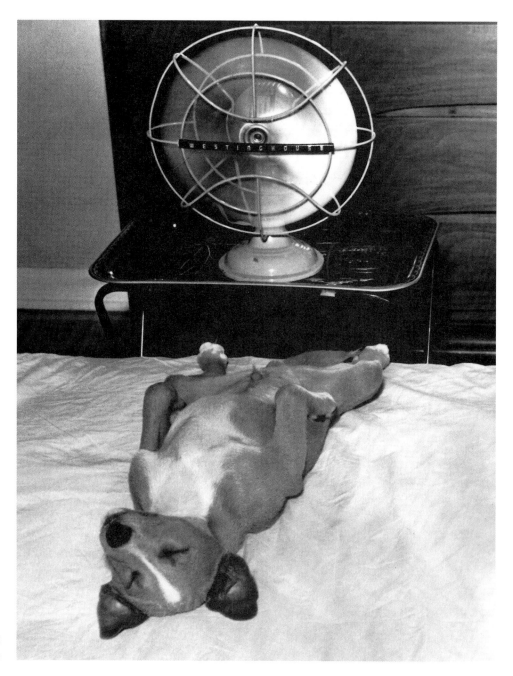

COOL BREEZE
Jack Tinney, 1960

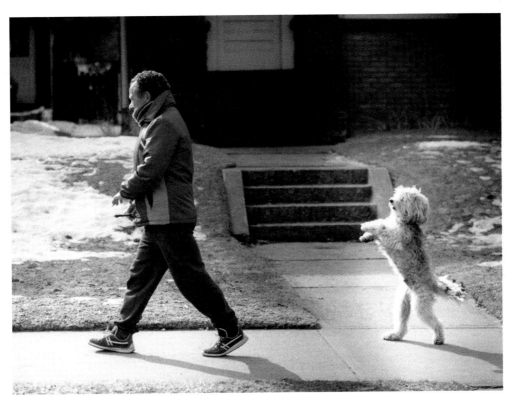

BUDDY GOES FOR A WALK
Veronica Henri, 1988

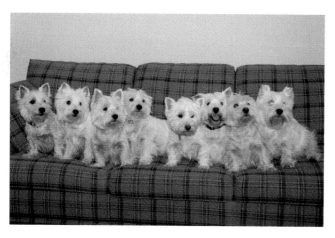

FAMILY REUNION
Richard Van Hoesen, 1993

CHRISTMAS MORNING
Ralph Crane, 1971

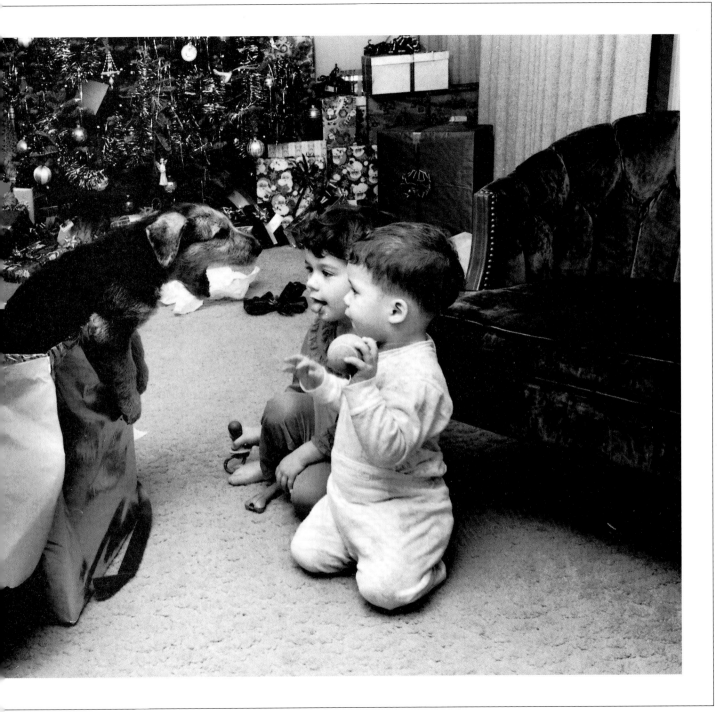

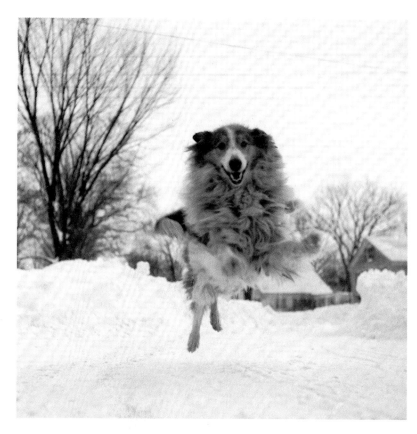

NEW ENGLAND SNOWSTORM
Robert W. Kelley, 1948

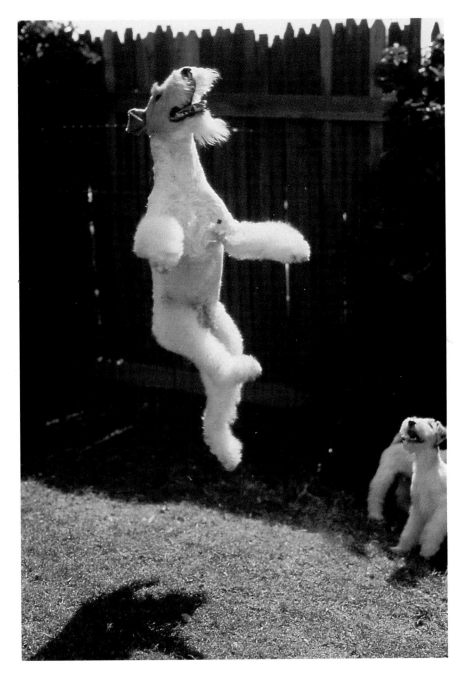

WIRE FOX TERRIERS
Leonard McCombe, 1971

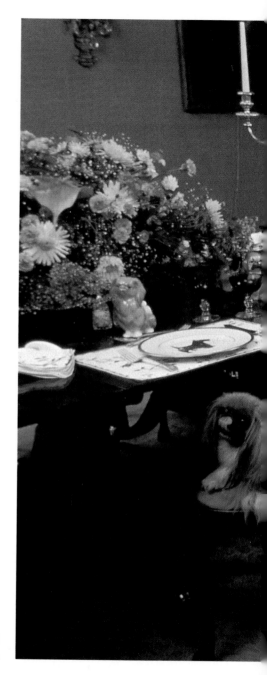

DINNER IS SERVED
Theo Westenberger, 1984

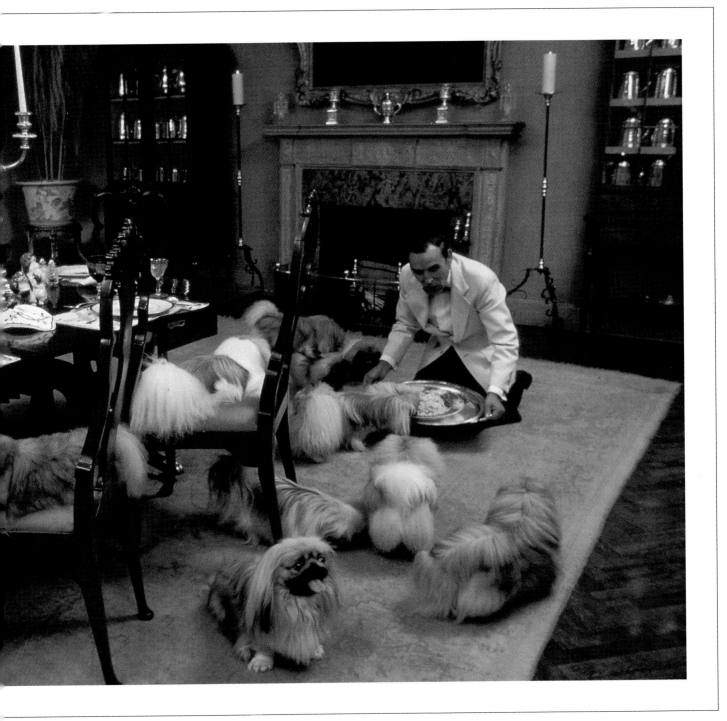

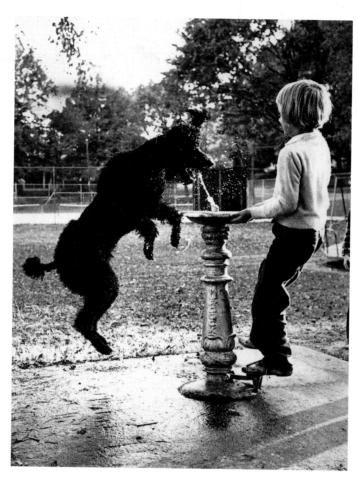

PROVIDENCE PARK
CHARLOTTE, NORTH CAROLINA
Declan C. Haun, 1961

AN AMERICAN BLOCK
HAMILTON, OHIO
Alfred Eisenstaedt, 1943

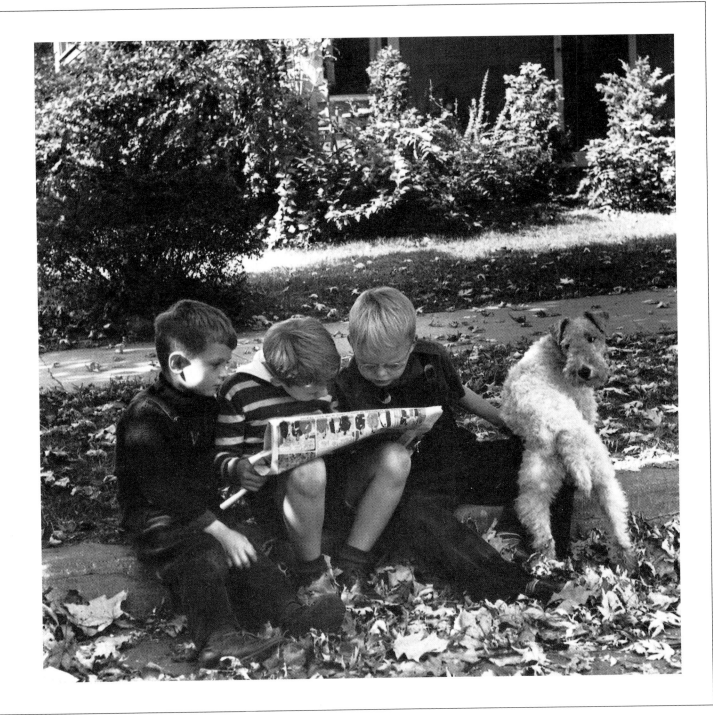

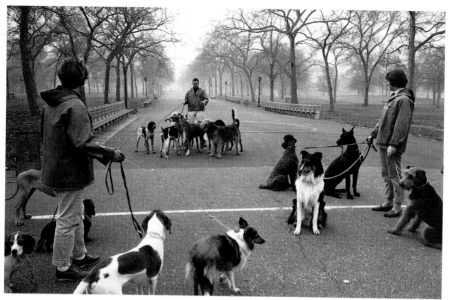

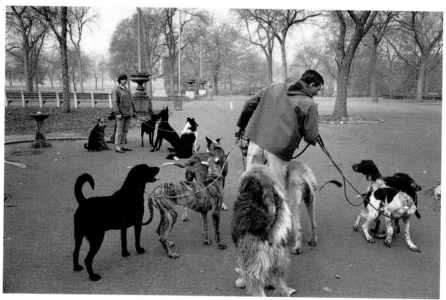

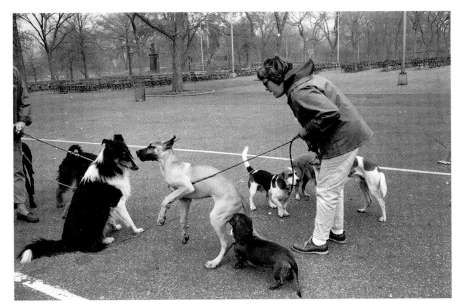

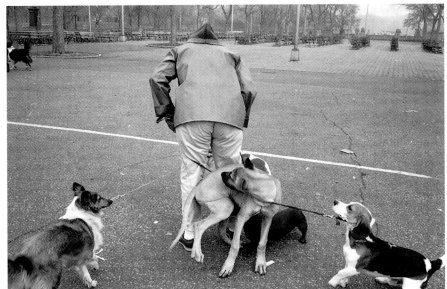

DOG WALKERS
CENTRAL PARK, NEW YORK CITY
Alfred Eisenstaedt, 1964

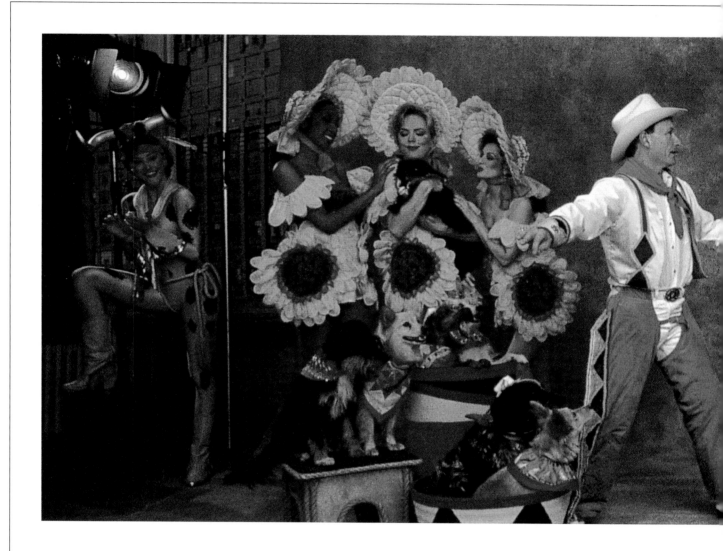

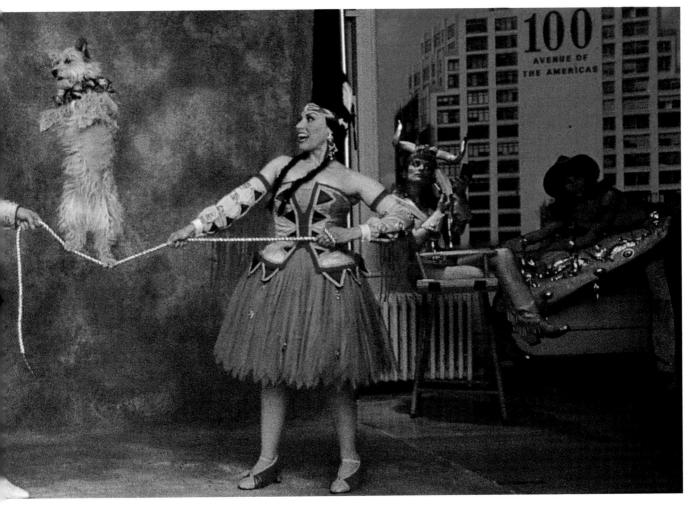

BRACKNEY'S MADCAP MUTTS
THE WILL ROGERS FOLLIES
Joe McNally, 1993

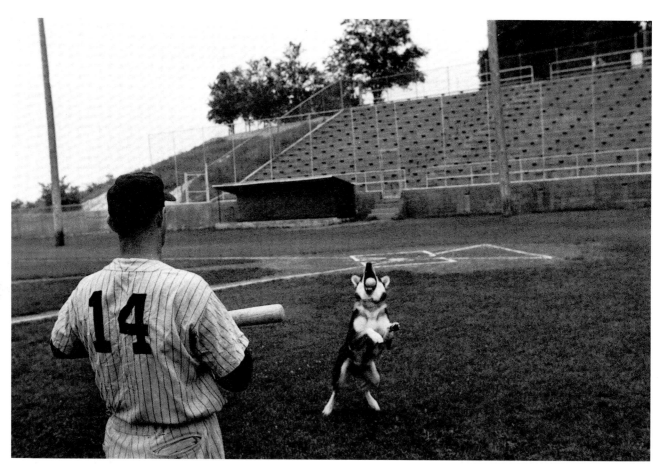

PREGAME WARM-UP
Loomis Dean, 1955

<div align="right">

DUDLEY LEAPS TO MAKE THE CATCH
Stephen Green-Armytage, 1979

</div>

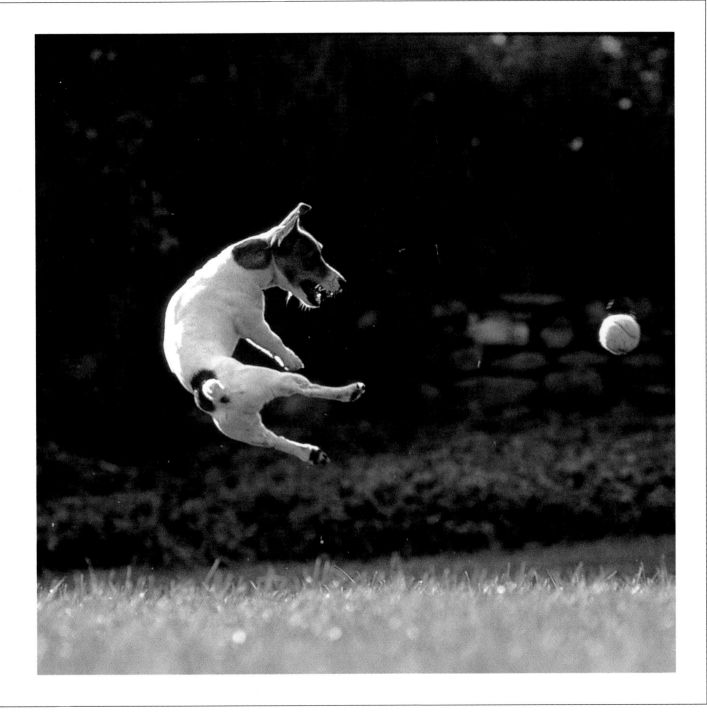

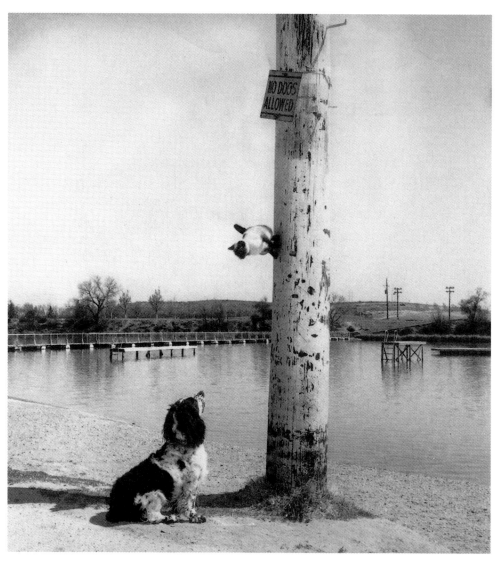

JUDGE GETS HISSED AT BY HONEY PIE
Dale Sedgwick, 1962

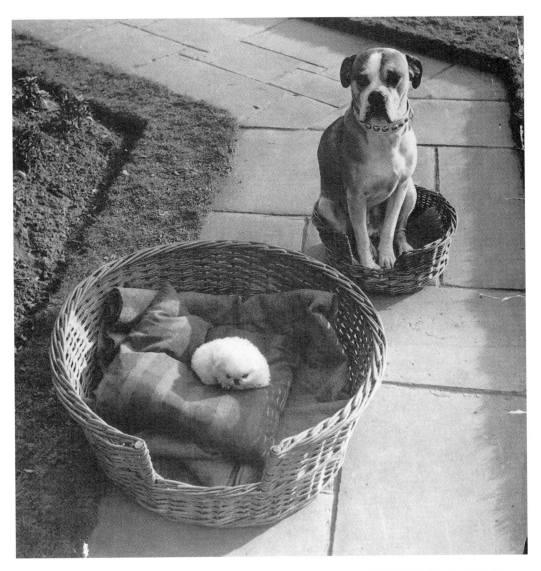

BONZO LOSES HIS BASKET TO MIGHTY ATOM
Black Star, 1954

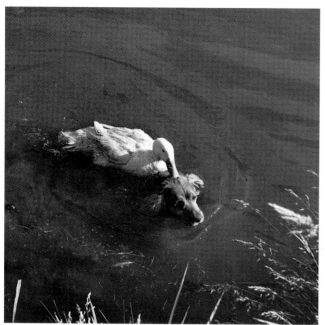

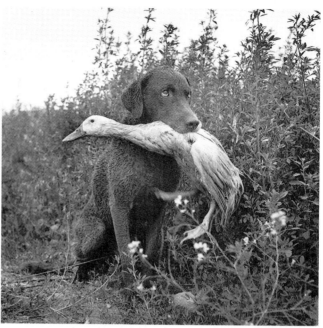

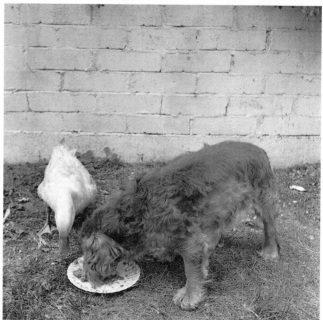

BEST FRIENDS
Loomis Dean, 1949

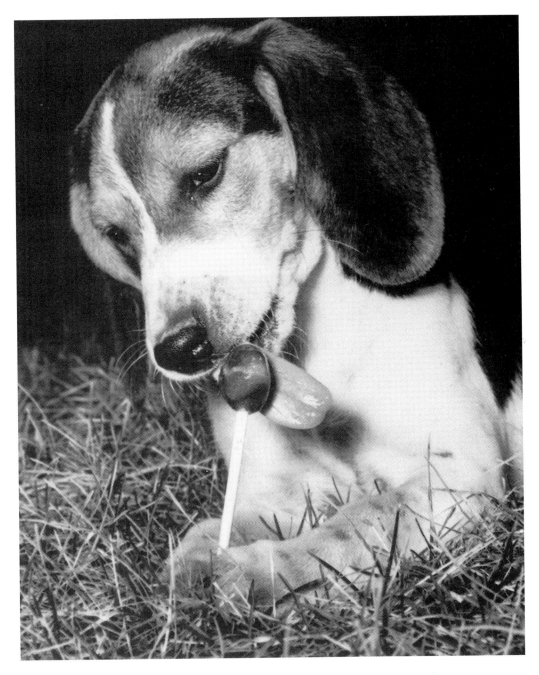

PEPI ENJOYS A
LOLLIPOP
Herbert H. Smith,
1962

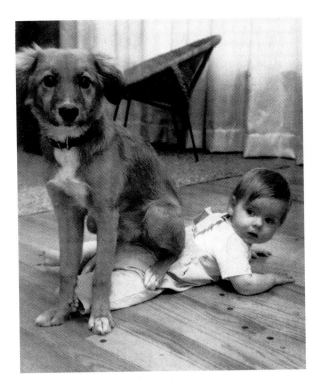

SPECS BABYSITS AMY
Eileen "Bonnie" Roberts, 1962

LADY PLAYS DEAD
Eugene Richards, 1990

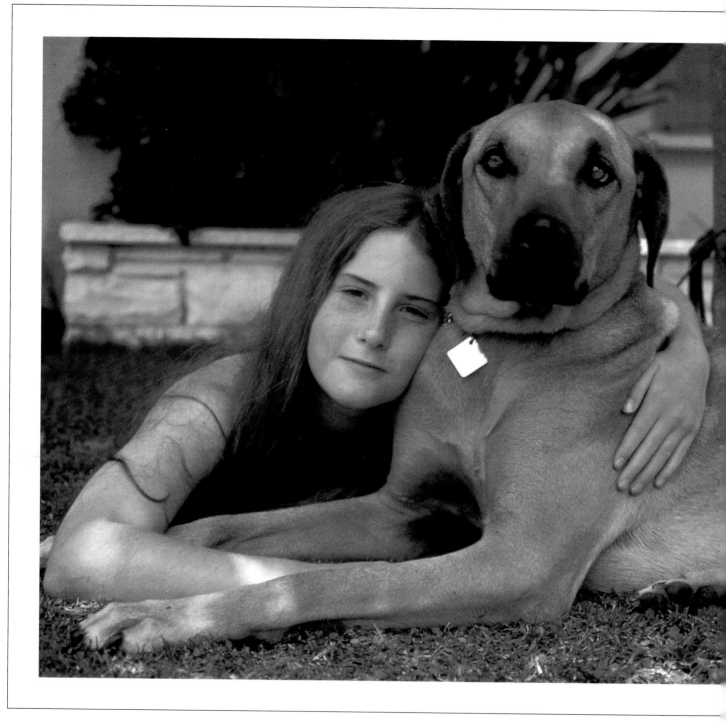

KATIE AND DOMBA
Ken Whitmore, 1964

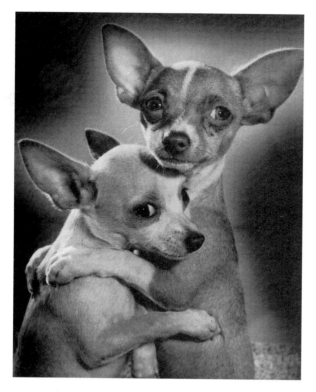

MISSY AND SAMBO PRACTICE
THE CHA-CHA
Robert C. Winter III, 1962

RAY AND MRS. LUBNER IN
BED WATCHING TV
William Wegman, 1981

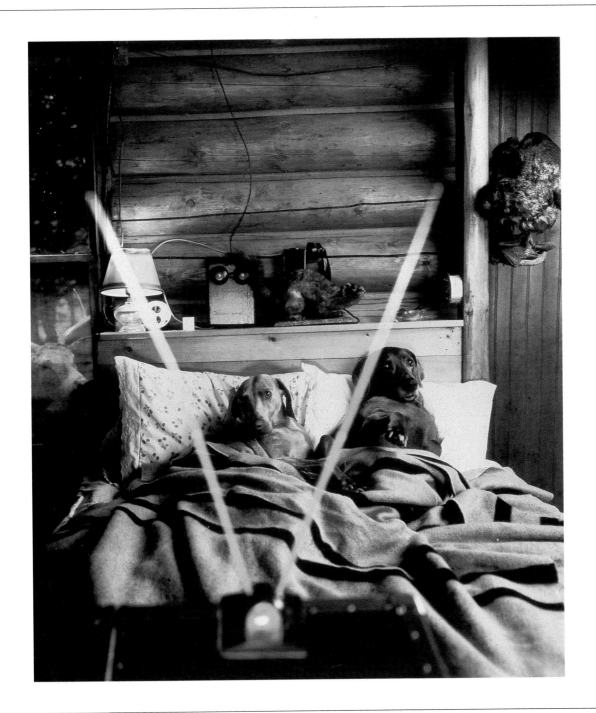



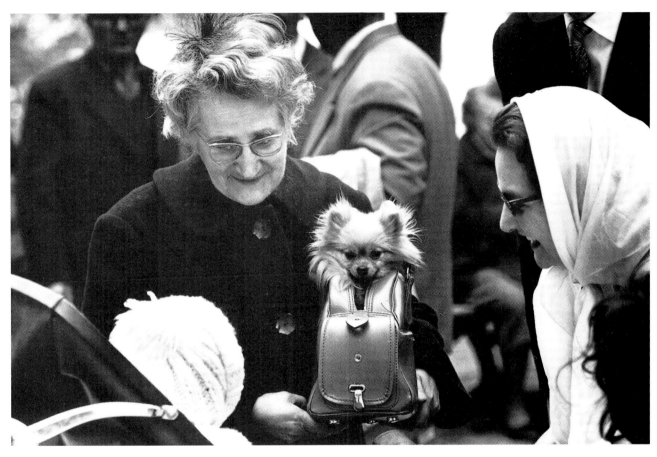

FIFI IN BAG
Alfred Eisenstaedt, 1963

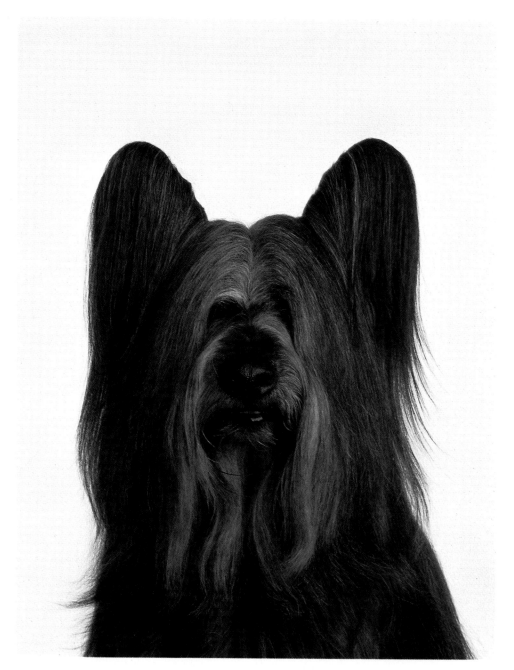

SKYE TERRIER
CHAMPION CICADASONG'S
CAIRNGORM ("CAIRY")
Joe McNally, 1994

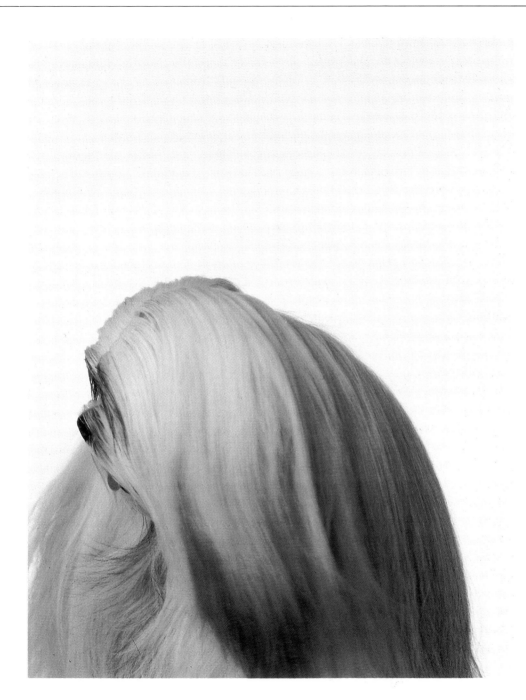

LHASA APSO
CHAMPION BIHAR'S
LADY IN RED ("JOH-NA")
Joe McNally, 1994

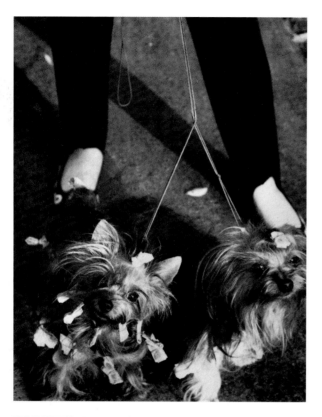

YORKIES WAIT FOR
THEIR BRUSH-OUT
Nina Leen, 1964

BANDIT UNDER THE
BLOW-DRYER
Theo Westenberger, 1984

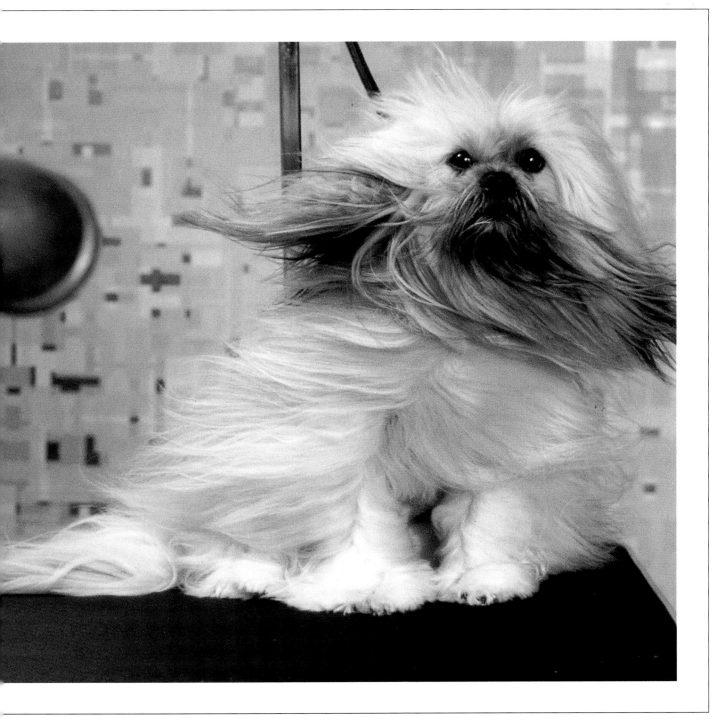

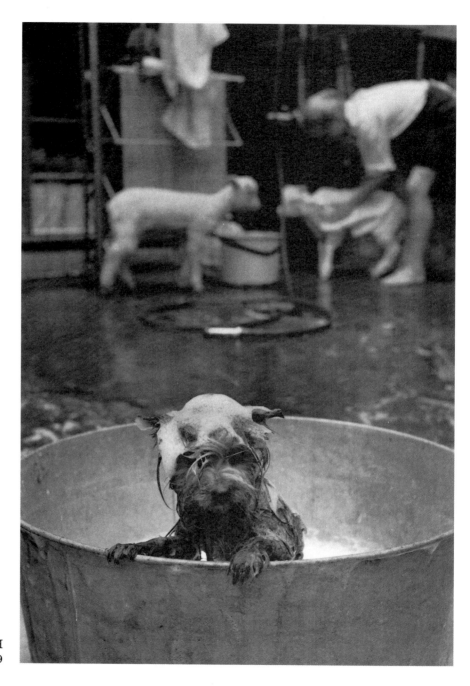

BUCKET BATH
Robert W. Kelley, 1959

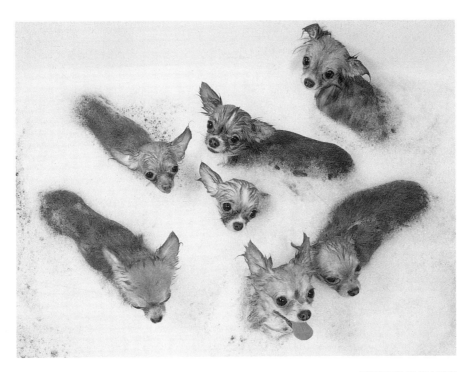

BUBBLE BATH
Nina Leen, 1954

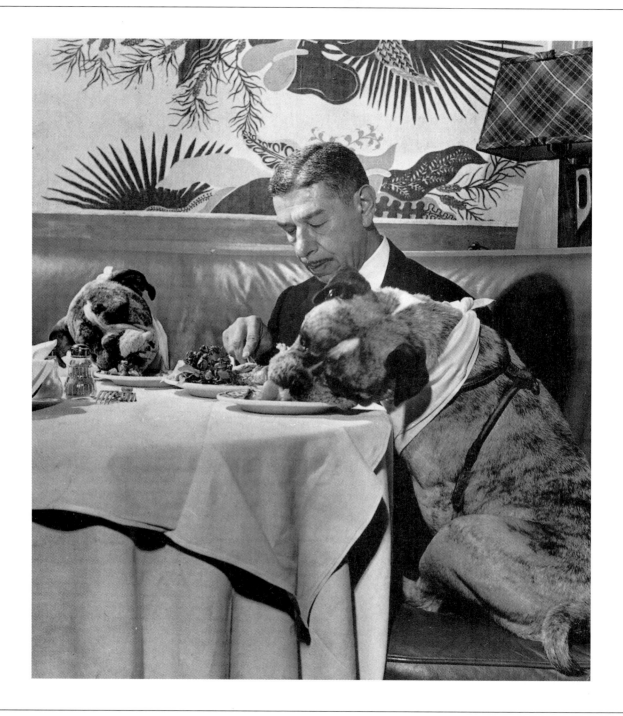

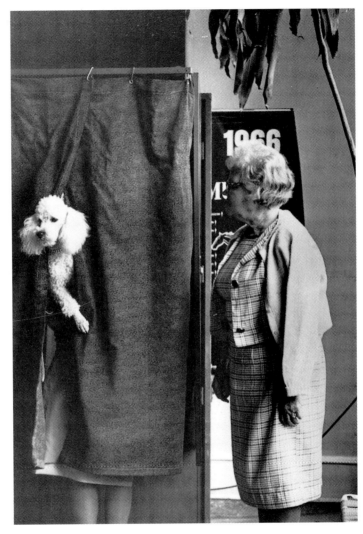

PIERRE GOES TO THE POLLS
Frederick A. Meyer, 1966

SOCRATES AND
MR. CONFUCIUS LUNCH
AT ROMANOFF'S
Ralph Crane, 1945

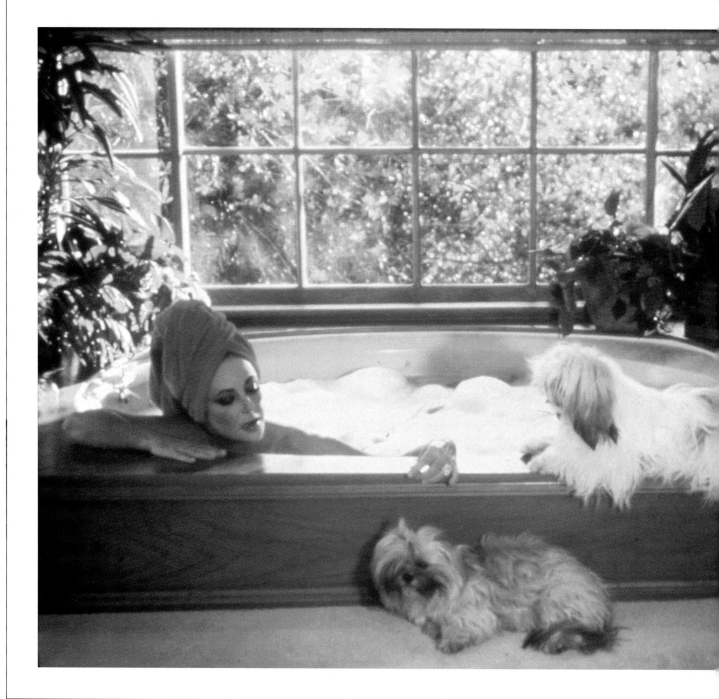

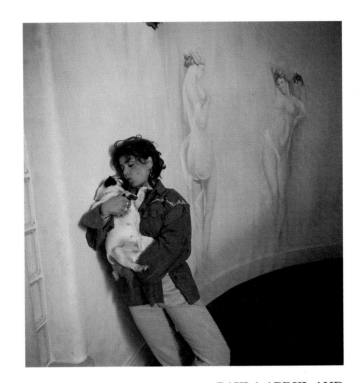

PAULA ABDUL AND
PUGGY SUE
Harry Benson, 1994

ELIZABETH TAYLOR WITH
REGGIE AND ELSA
Norman Parkinson, 1982

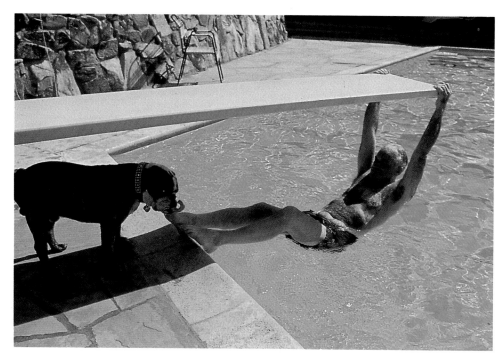

BARRY M. GOLDWATER
AND CYCLONE III
Bill Ray, 1964

LYNDON B. JOHNSON AND YUKI
Yoichi R. Okamoto, 1968

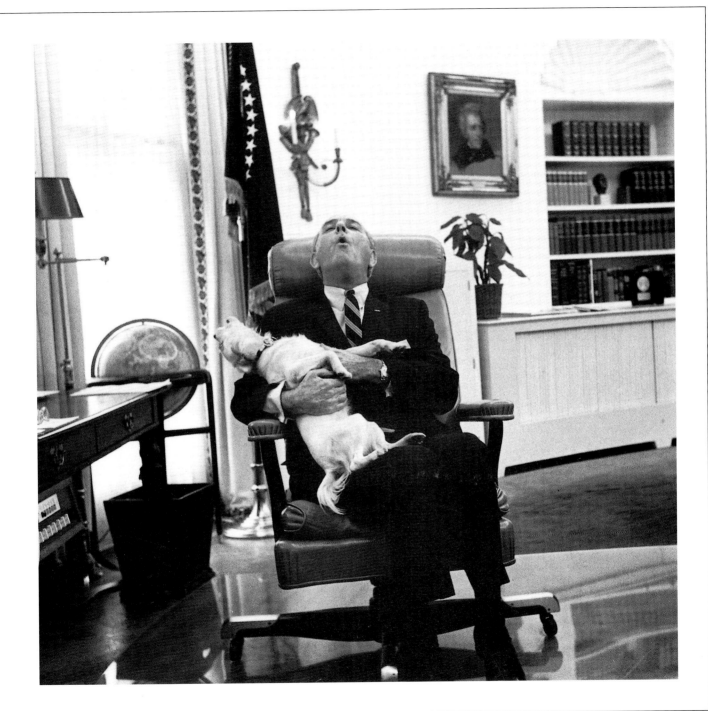

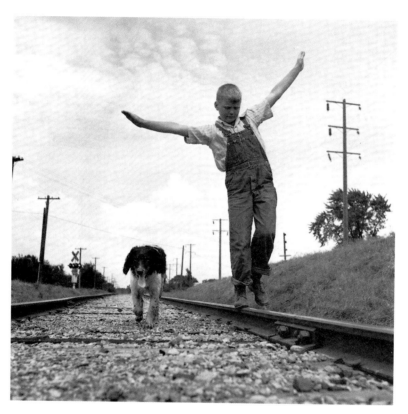

A BOY AND HIS DOG
OSKALOOSA, IOWA
Myron Davis, 1945

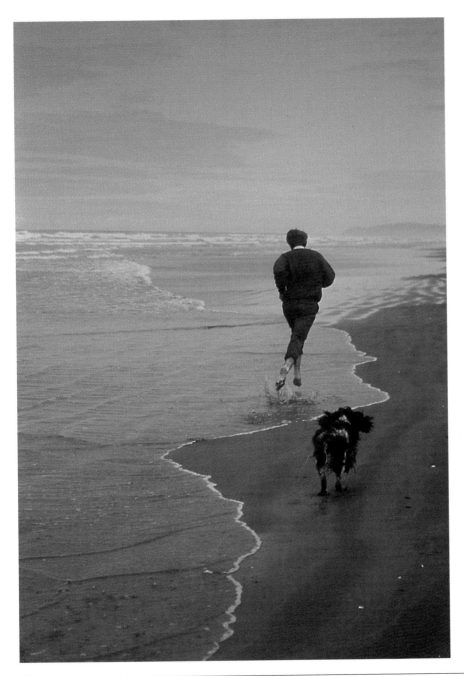

ROBERT F. KENNEDY
AND FRECKLES
Bill Eppridge, 1968

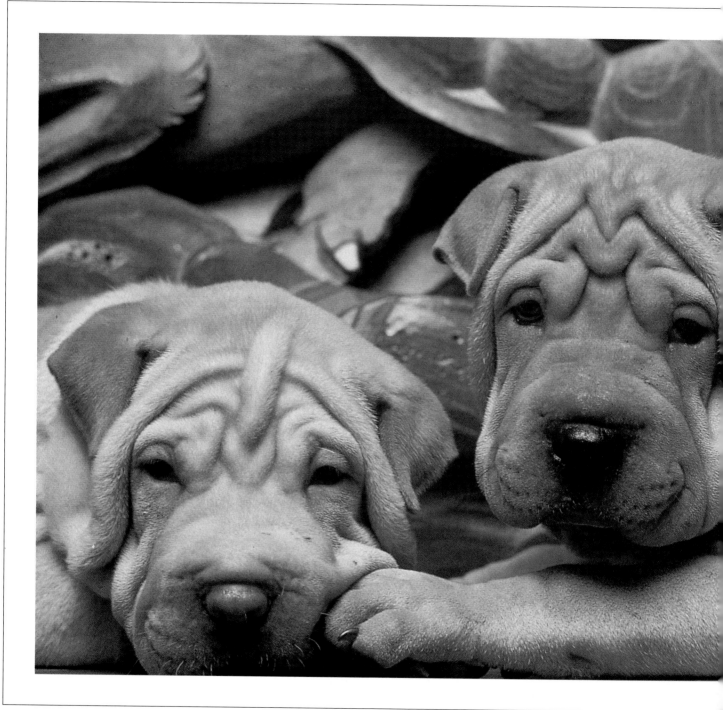

SHAR-PEI PUPPIES
Stephen Green-Armytage, 1979

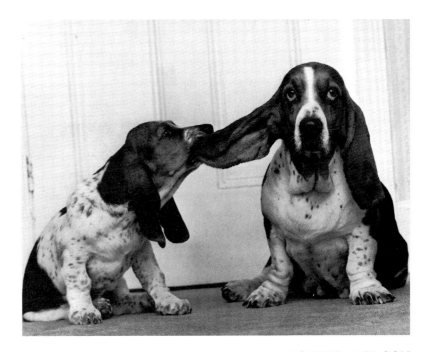

MOTHER AND SON
Keystone, 1966

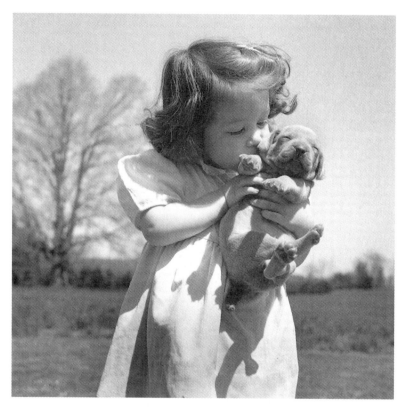

PUPPY LOVE
Bernard Hoffman, 1950

<div style="text-align: right">

HERMAN GIVES CHRIS A KISS
Bill Bridges, 1961

</div>

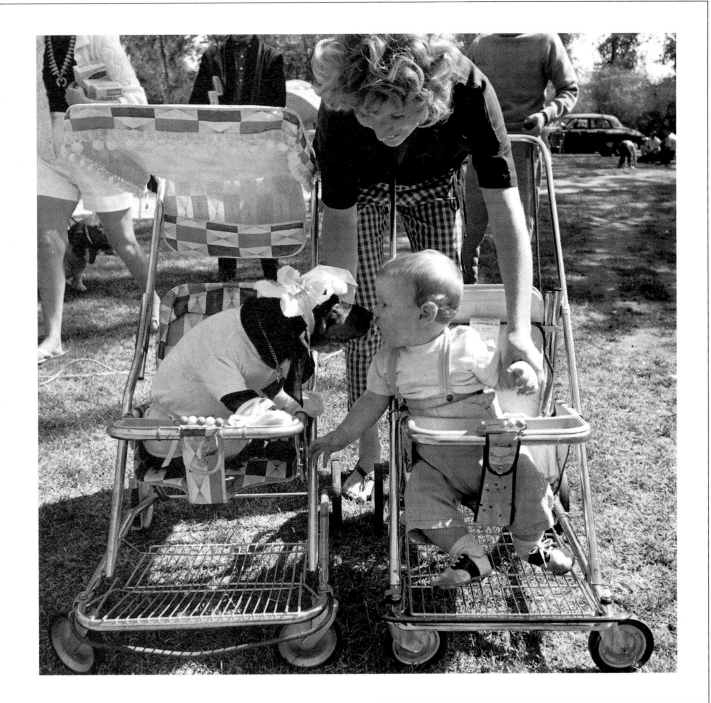

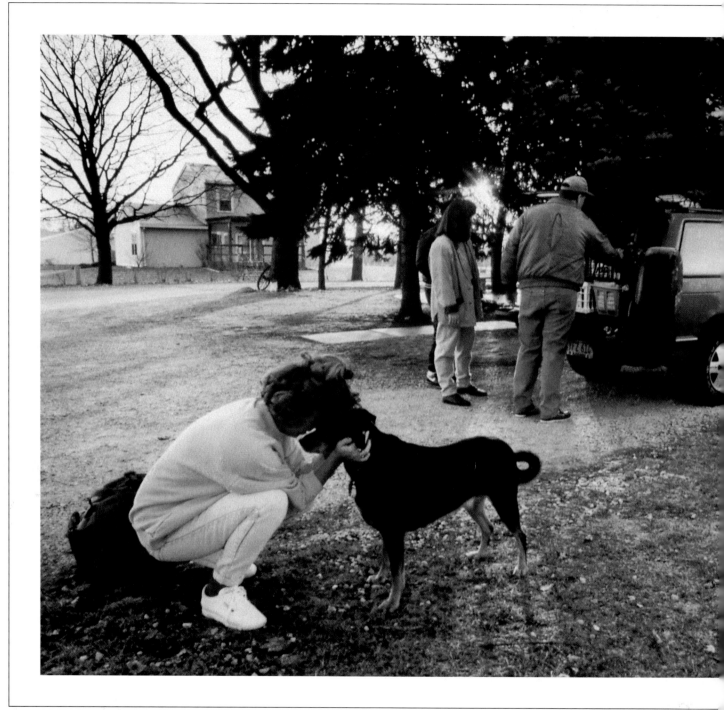

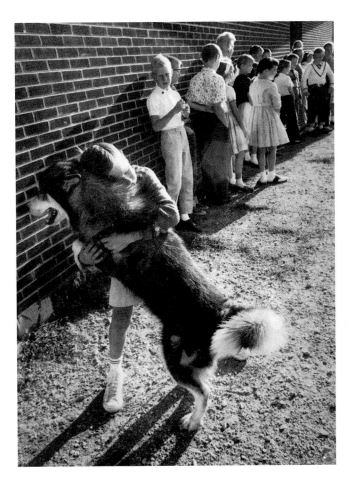

THE FIRST DAY OF SCHOOL
Arthur Shay, 1962

JENNY LEAVES FOR COLLEGE
Andy Levin, 1992

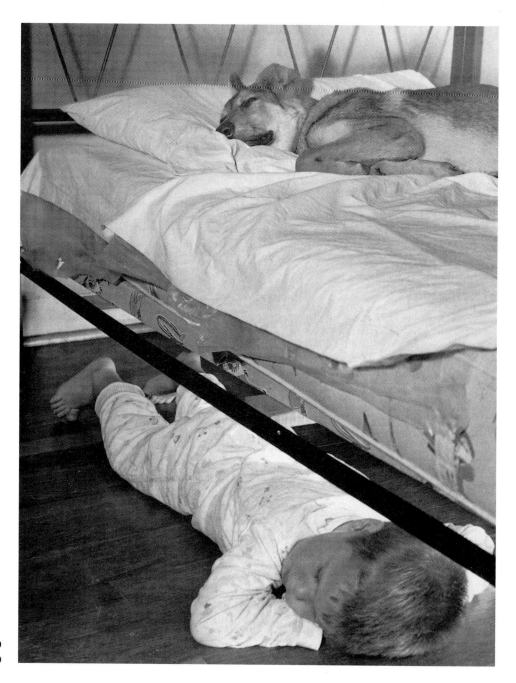

JUDY GETS THE BED
Bob Williams, 1960

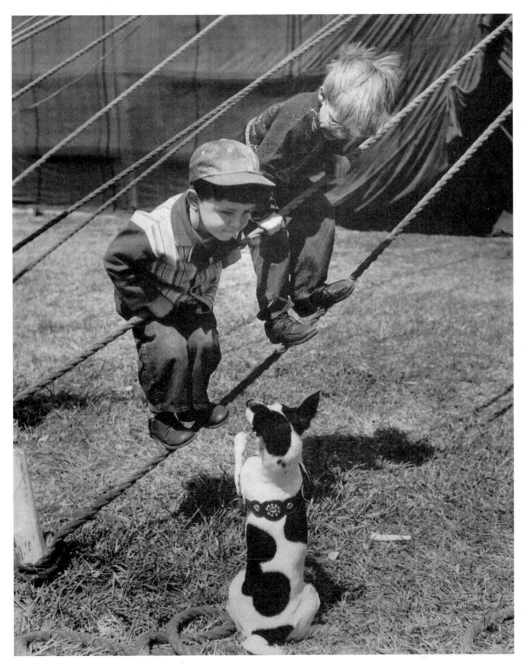

AT THE CIRCUS
Nina Leen, 1949

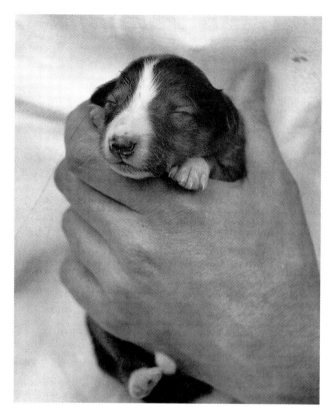

SHETLAND SHEEPDOG PUPPY
Nina Leen, 1950

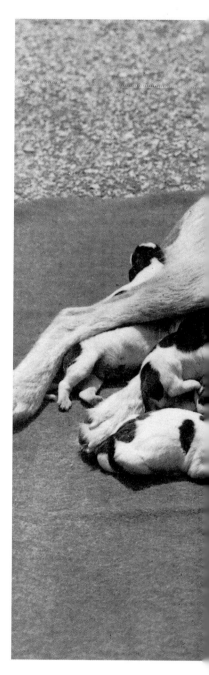

MOTHER OF TWENTY-THREE
The Philadelphia Inquirer, 1944

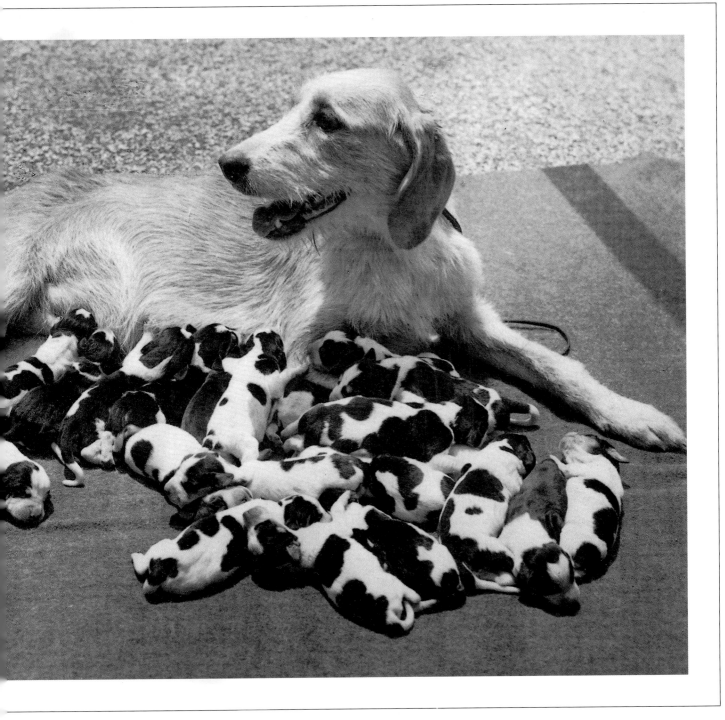

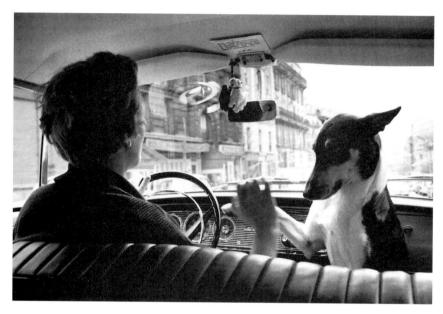

DRIVING IN PARIS
Alfred Eisenstaedt, 1963

CANINE COPILOT
Theo Westenberger, 1984

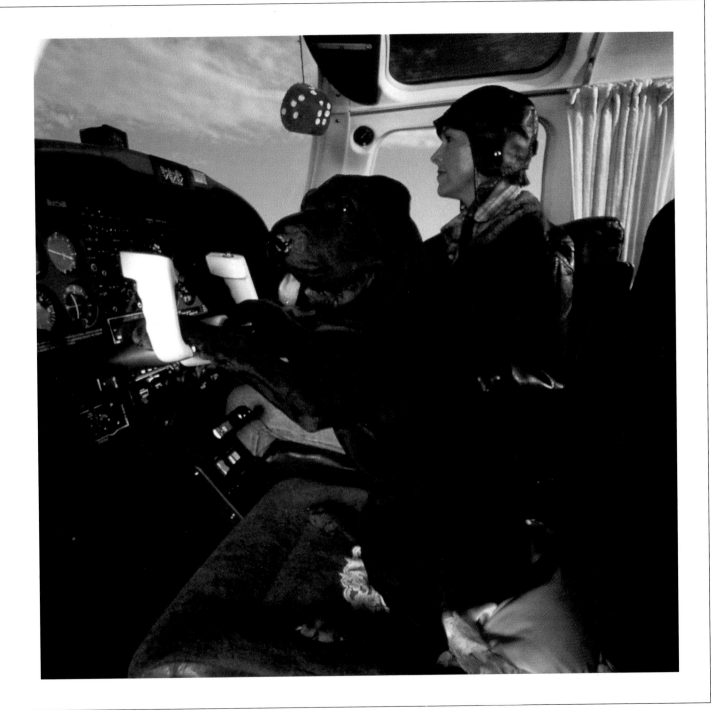

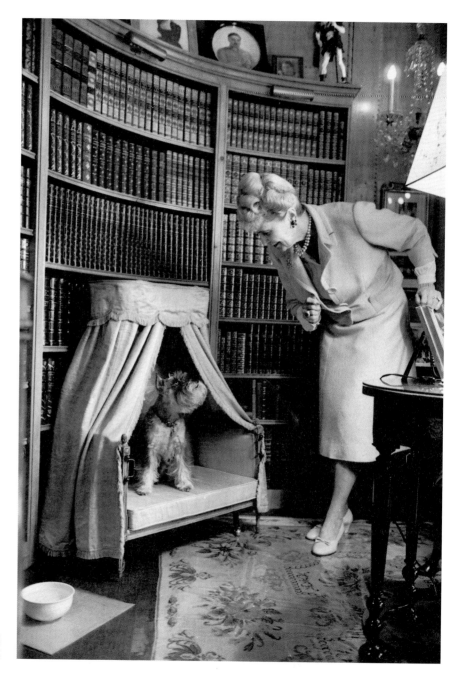

SCAMPI'S HOUSE
Alfred Eisenstaedt, 1965

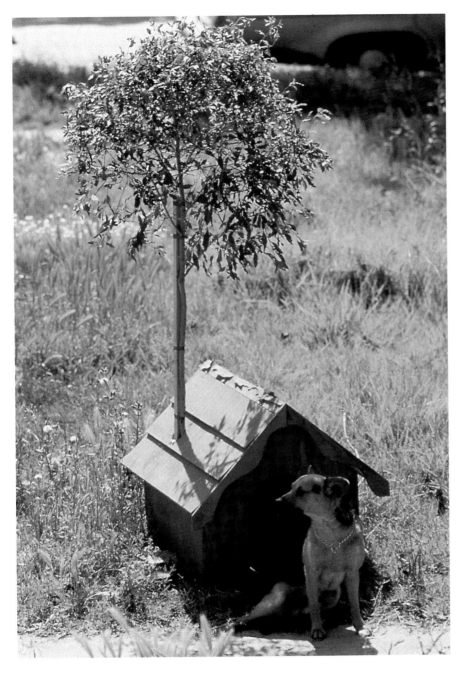

SKIPPER'S HOUSE
David McEnery, 1989

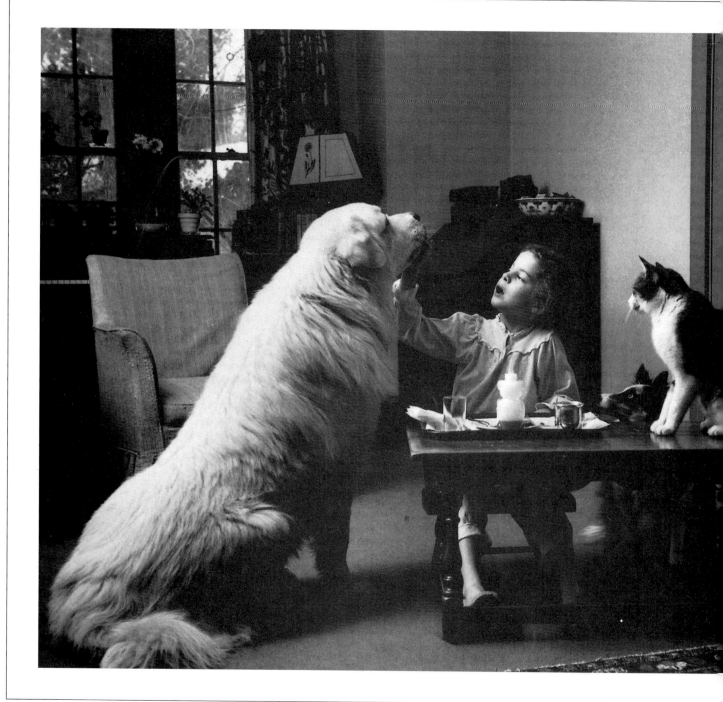

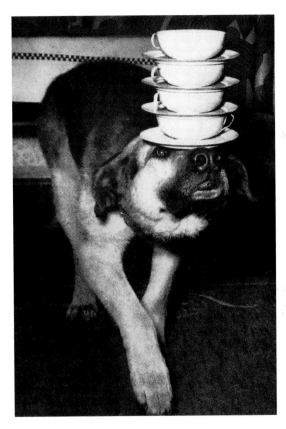

COFFEE FOR FOUR
Keystone, 1954

TEA PARTY
Esther Bubley, 1961

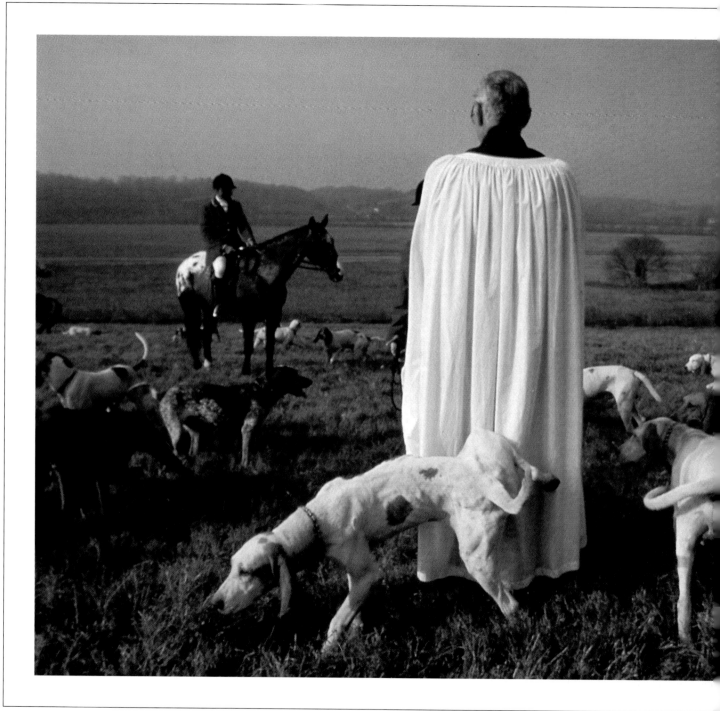

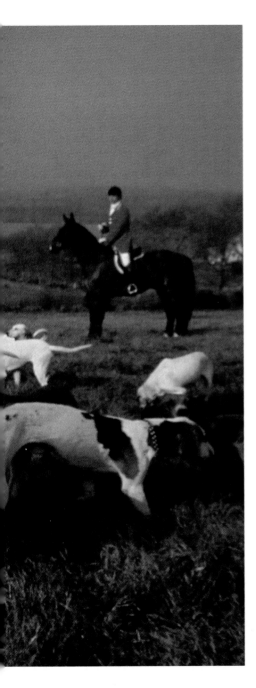

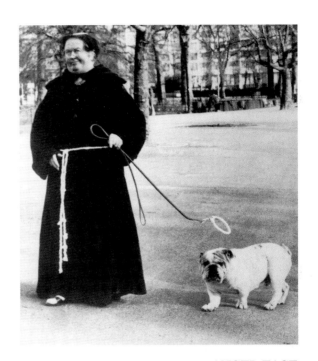

ANGEL FACE
Kent Gavin, 1977

BLESSING THE FOXHUNT
Fritz Hoffmann, 1992

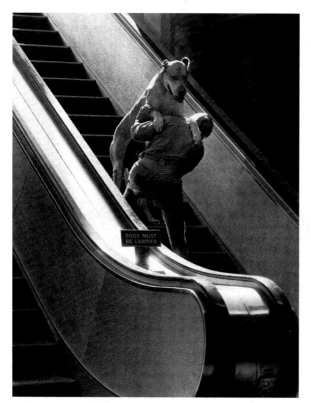

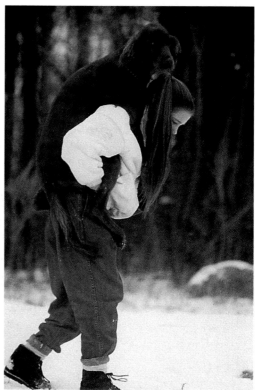

ROCKY GETS A LIFT
David McEnery, 1987

MURPHY GETS A LIFT
Colin McConnell, 1989

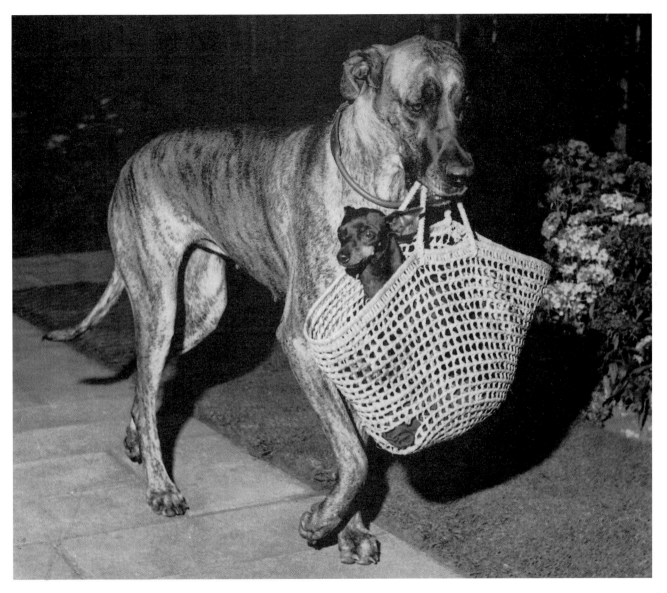

JUNIA CARRIES MINI-MINA HOME FROM THE MARKET
Archive Photos, 1965

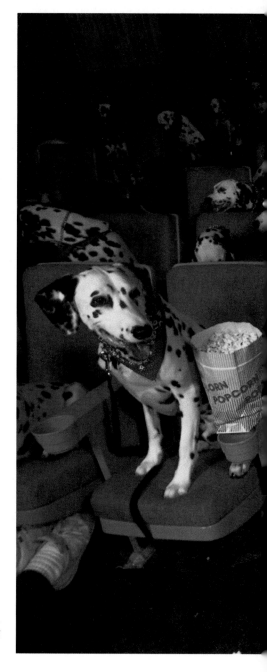

DALMATIANS AT A SCREENING
OF *101 DALMATIANS*
Melanie Rook D'Anna, 1991

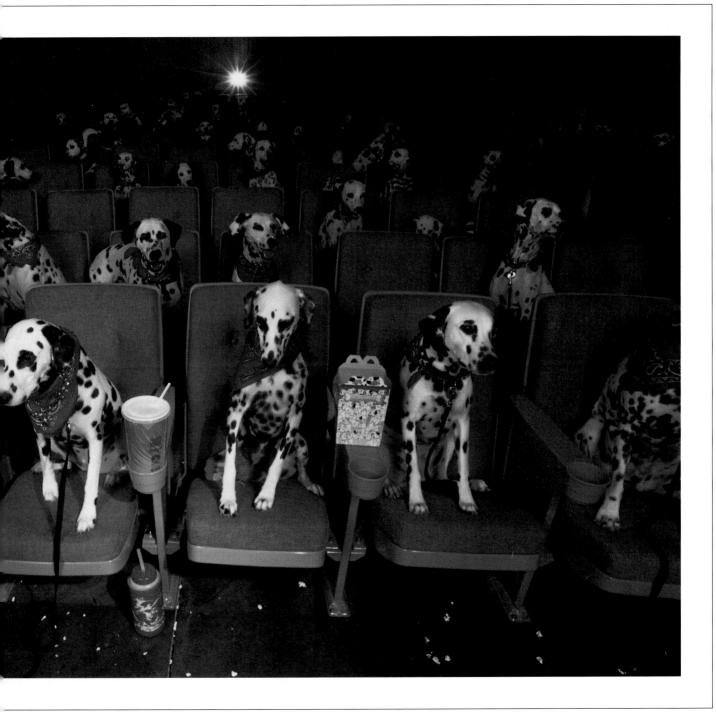

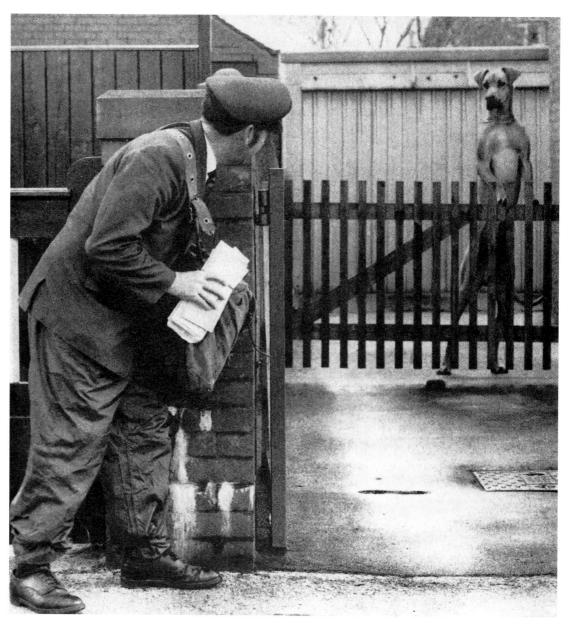

BRUNO VERSUS THE MAILMAN
Syndication International, 1972

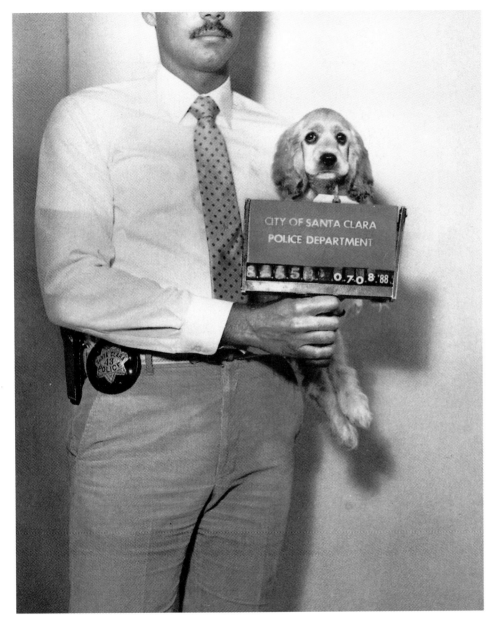

DOG TAGGED
Officer John Martin, 1988

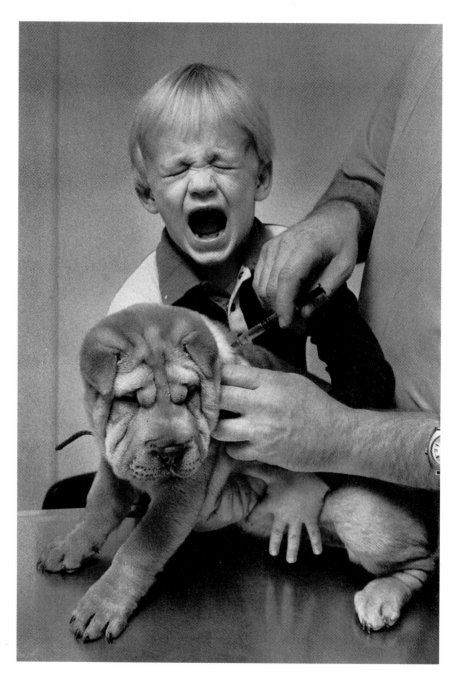

BEAUTY GETS HER SHOTS
Janet Kelly, 1987

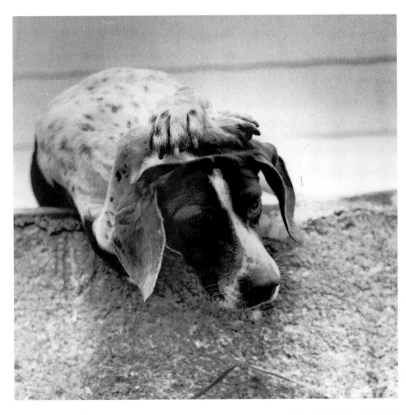

MY ACHING HEAD
Joe Scherschel, 1960

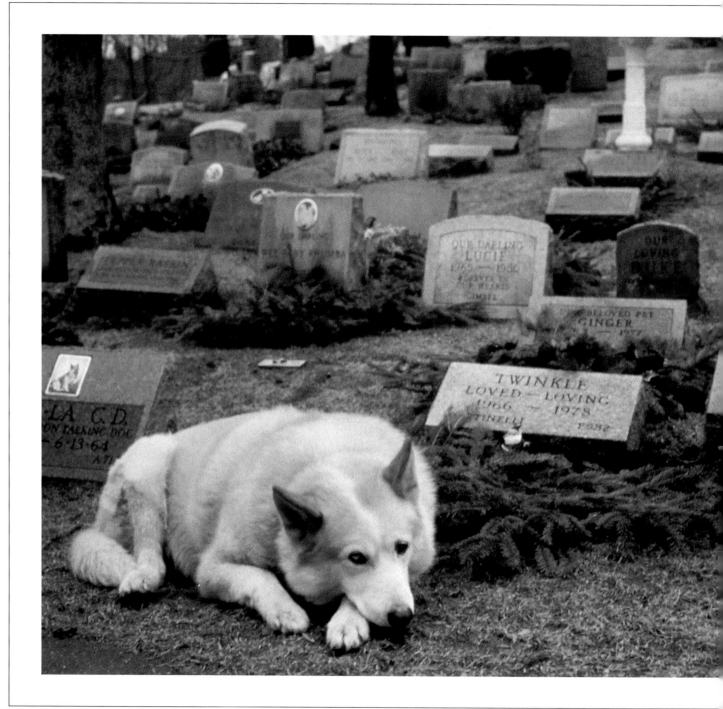

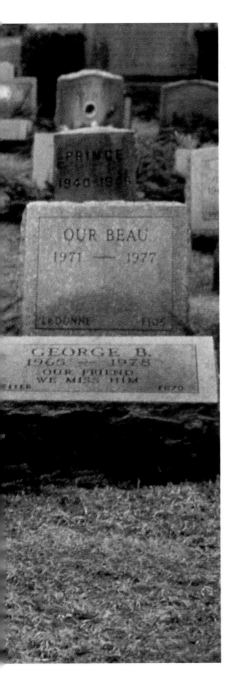

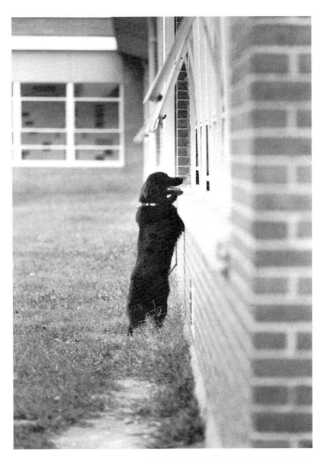

LOOKING FOR A FRIEND
Bob Gomel, 1962

BRANDY VISITS THE GRAVE OF A FRIEND
Jane Evelyn Atwood, 1986

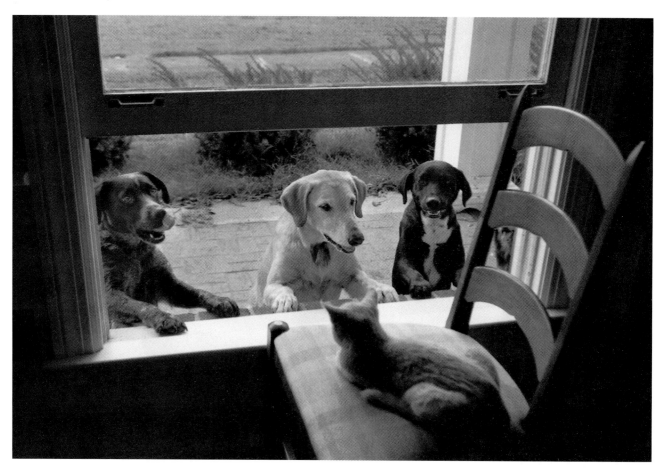

KITTY IN THE WINDOW
Katharine Farmer, 1993

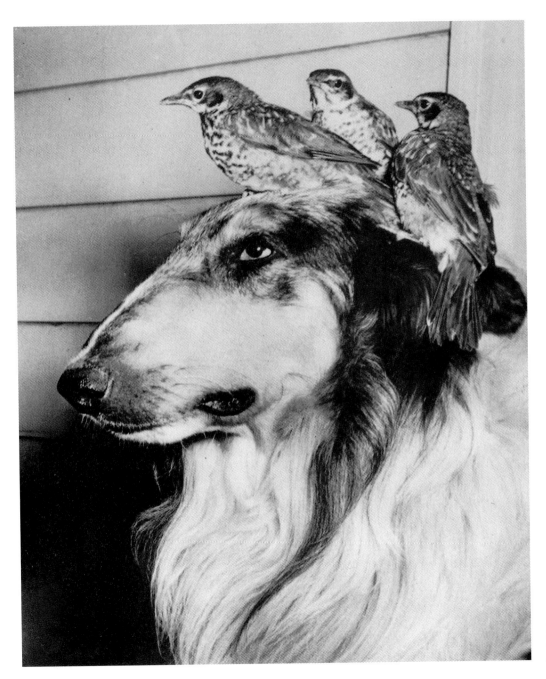

DUSTY'S BIRD
BONNET
John Ericksen, 1955

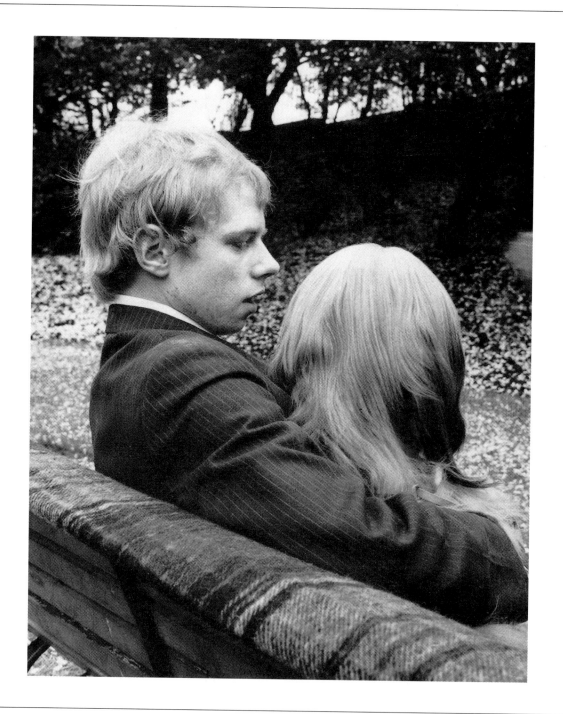

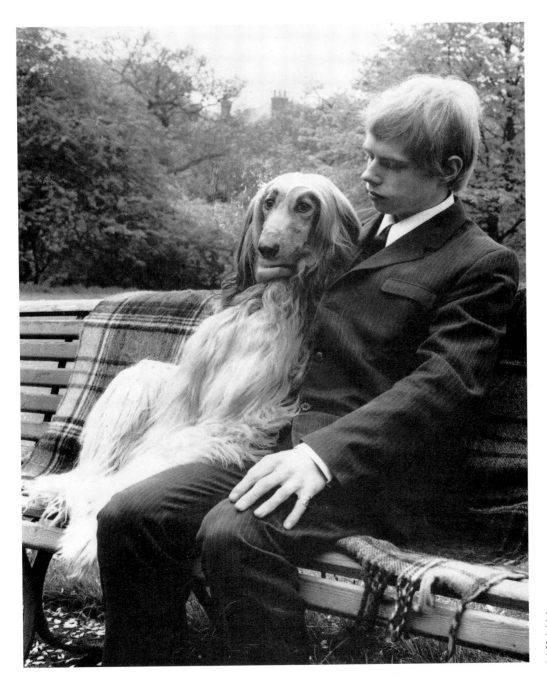

PAUL AND DENZA
PRESTWICH, ENGLAND
Syndication
International, 1967

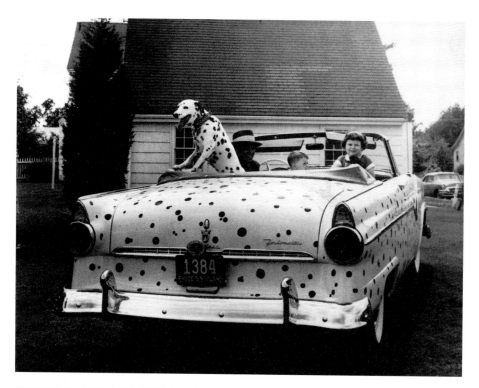

SKIPPER AND FAMILY
GO FOR A DRIVE
Raymond H. Nelson, 1955

SISSY AND FAMILY GO
BOATING ON LAKE AFTON
A.Y. Owen, 1959

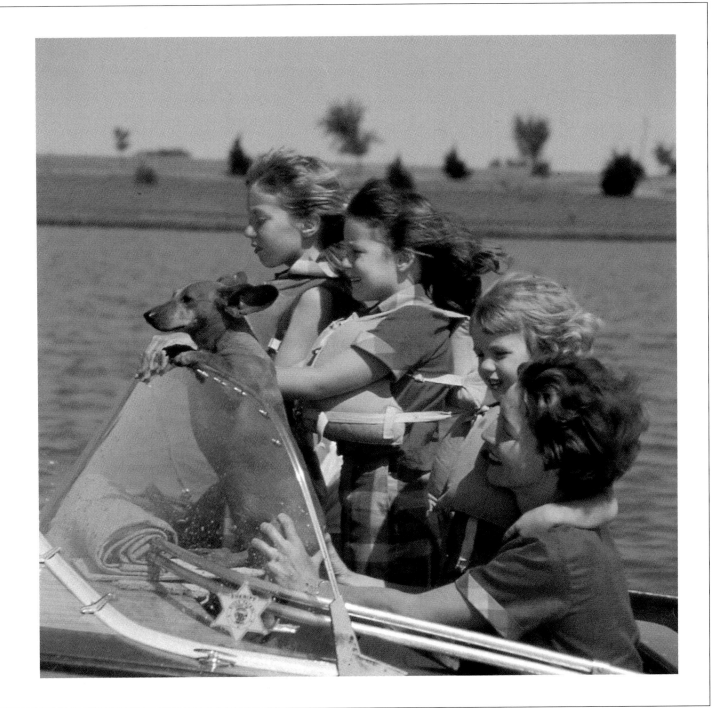

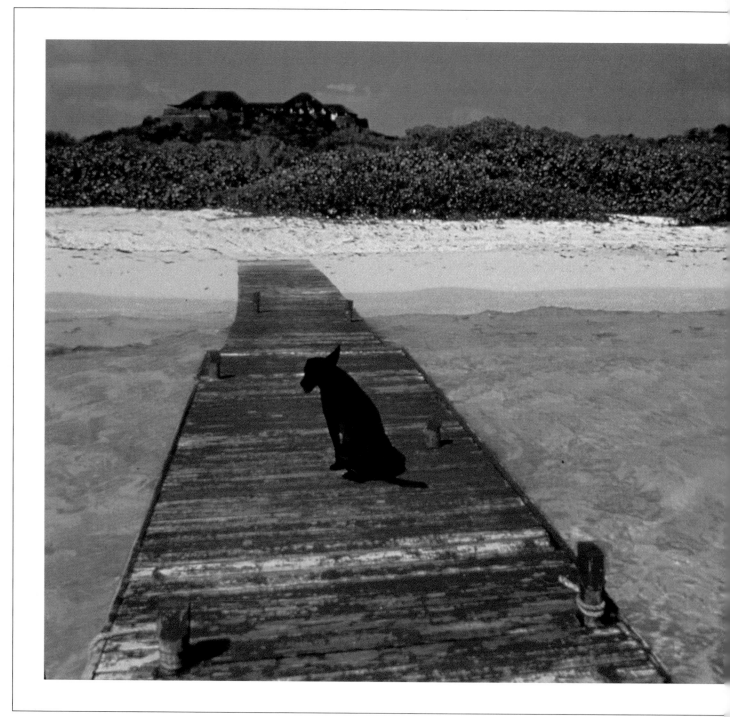

ON THE DOCK AT NECKER ISLAND
Lee Crum, 1989

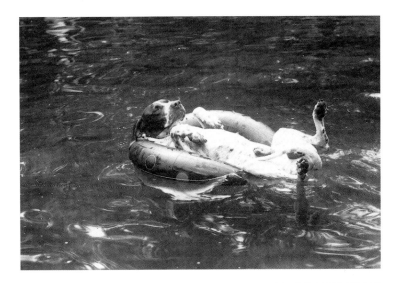

THOR RELAXES
George P. Russell, 1967

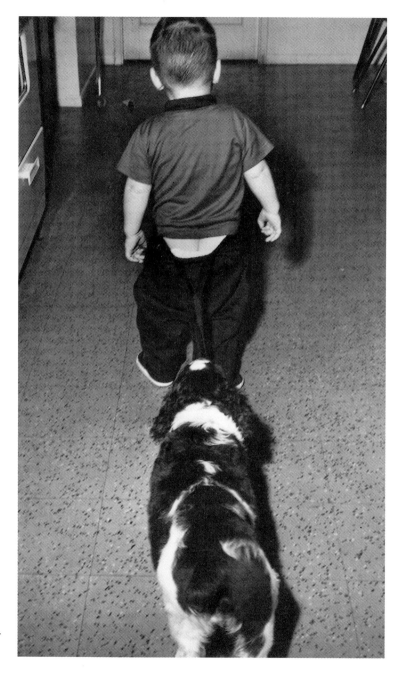

TODDLER AS PULL TOY
Nyle Leatham, 1961